toulouse-lautrec

toulouse-lautrec

Text by
JOSEPH-ÉMILE MULLER

SPURBOOKS LTD
LONDON

Published by
SPURBOOKS Ltd
LONDON, 1975
ISBN 0.902875.74.4
Printed in Italy

A Precocious Start Born on November 24, 1864, at Albi, Henri
Toulouse-Lautrec died before he was thirty-
seven. However, he was active as an artist for
more than twenty years because his talent ripen-
ed early. He drew from his childhood on, filling
his notebook when he was a student with quick,
suggestive sketches. He drew like his father and
two uncles, and perhaps he would not have
become any more of an artist than they if he
had not been the victim of accidents that
abruptly cut off any possibility of his patterning
his life after his father's.

There was something a trifle anachronistic
about his father's life-style. His private wealth
made it unnecessary for him to work, and, in
addition to horses and women, he loved falcon-
hunting and whatever was tinged with a sense of
eccentricity or travesty. Was it really true that
his ancestry could be traced back to the Counts
of Toulouse, famous already during Charle-
magne's time, and who became a subject of dis-
cussion again at the time of the First Crusade as
well as during the repression in the thirteenth
century of the Albigensian heretics whom these
counts struggled to defend against the Pope?
It would perhaps be prudent not to take these
affirmations at face value. Nonetheless, Al-
phonse de Toulouse-Lautrec-Monfa belonged
to an old French family, as well as his wife,
Adèle Tapié de Céleyran, who was also his
cousin. As for his son, in 1878 he fell on the
dining room floor in his family's house and

broke his left leg. The following year, while walking with his mother, he tumbled down a shallow ravine and broke his right leg. These two fractures made him an invalid who could hardly walk and gave him the grotesque appearance of a dwarf. For while the rest' of his body grew normally, his legs remained short and spindly. In themselves, these falls were not serious, and the fact that they produced such an effect obviously indicates some anomaly, a sickness of the bone structure that doctors have called by different names. But whatever the cause may have been, the result was there, brutal and inexorable, an infirmity that would accompany Lautrec throughout his life, whose course it would determine, until finally it led him to his death. Stimulating the desire to seek forgetfulness in debauchery, it pushed Lautrec toward the poisons that eventually killed him.

When Lautrec graduated from secondary school and, in 1881, was given permission to become a painter, his first master was a friend of his father, René Princeteau, who loved to depict horses and hunting scenes. Lautrec had drawn horses even before he became Princeteau's student; he showed them galloping, trotting, jumping, with or without a rider, harnessed to a carriage, alone or in tandem. What fascinated him most, from the beginning, were their movements. Since the beginning, Lautrec had been fascinated by movements, whether of humans or animals, and throughout his career he observed

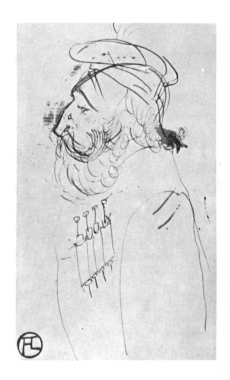

them with passionate attention. The drawings
he did as a schoolboy reveal his mocking spirit,
the pleasure he took in rendering positions that
were not only characteristic but funny, capable
of evoking a smile or an ironic remark. Natural-
ly his infirmity served only to reinforce this
tendency, all the more so in that Lautrec was a
sensuous person who had no intention of resign-
ing himself to his fate but desired to live intense-

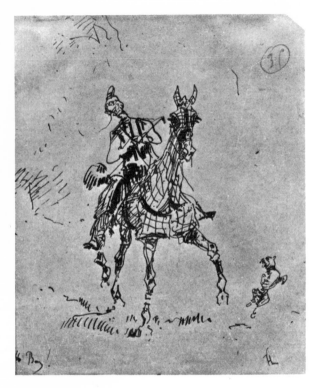

Horseman and dog
1875-1876
Drawing
Albi museum

ly. How was it possible for him not to look
with envy at all the things that excited him with-
out his being able to participate in them? How
could he not feel the need to take revenge by
bringing out their derisory aspects? It was only
natural that he took a great interest in the
behavior of his contemporaries and studied their
amusements, distractions and pastimes—every-

thing available to them, for their pleasure or boredom, but from which he was excluded.

Lautrec was scarcely fourteen when he realized that he was incapable of depicting "views." "My trees," he wrote to a friend, "are like spinach." And he went on to specify that his "menu is not very varied. There are two choices: horses and sailors; the first are more successful." This is not surprising since Lautrec painted horses in motion, so that their form could be approximated by means of vivid touches and patches. It was in this manner that, in 1881, he represented *The Count Alphonse de Toulouse-Lautrec driving his mail coach to Nice* as well as *The Races at Chantilly*, in which he depicted himself in a carriage next to his cousin Louis Pascal and Princeteau. Here and there, there seems to be something frantic about the galloping horses: they run as if they were being whipped by a demon.

First Years in Paris

Early in 1882 Lautrec moved with his mother to Paris in order to work at Princeteau's. A few weeks later he entered the studio of Bonnat, the cold, official portraitist. Then, from 1883 to 1887, he studied with Cormon, who treated subjects borrowed from the Bible, history and prehistory. What did Lautrec think such academic painters could teach him? To start with, a surer knowledge of his craft that would enable him to go beyond the vagaries of improvisation.

He also met at Cormon's other young artists such as Anquetin, Emile Bernard and (in 1886) Van Gogh, who all felt that a new art had to be created in opposition to the official style of painting that then prevailed. Lautrec's spirit was far too free and too curious for him to confine himself to what he could learn at school. A caustic observer of Parisian life, he was naturally interested by Forain, but he was even more attracted by the Impressionists, especially those who portrayed scenes of Parisian life, Renoir, Manet, and Degas. Although he did not meet Degas until 1885, he was profoundly influenced by his work. Around 1883 he painted a few pictures, especially portraits of his mother, in which the spirit of Impressionism was very much in evidence. He also painted a few other pictures in a more traditional style. In short, until 1889 Lautrec was still searching for his own identity; now a linear, now a more painterly style dominated. One of the most individual works that he painted using this pictorial style was *la Blanchisseuse* of 1889. Lautrec's personality expressed itself less in the style than in the physiognomy of the young girl and her attitude. She has stopped working and with a proud, savage look she gazes at the window like a prisoner might gaze at the sky from behind the bars of his cell.

To sum up, Lautrec's most characteristic contribution is best illustrated by works that might almost be described as color drawings,

Dancer adjusting
her maillot
1889. Drawing
Albi museum

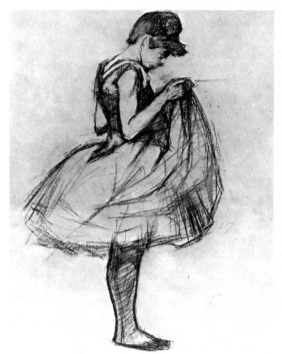

such as the portraits of Suzanne Valadon (1883),
of Van Gogh (1887), of Hélène Vary (1888), or
la Buveuse (1889) in which Suzanne Valadon was
again the model (the artist carried on a stormy
affair with her for some time). In these works
Lautrec provided incontestable proof that the
line, on account of its clear, concise, elliptic
and incisive qualities, was more suited to his
genius than spots of color, the effects of impasto,
or touches.

Are we right in seeing an influence of Van Gogh in Lautrec's work? Although there are definite similarities between the pictures Van Gogh painted in 1887 and certain of those that Lautrec finished the same year or a little later, in addition to stylistic resemblances (the lines and crosshatchings that activate the color field), there is no doubt that in Lautrec's work the lines are generally longer and less compact than in the Dutch painter's work. Rather than being energetically juxtaposed, the lines seem scribbled on by a light and a trifle "vagabond" hand. What is more, the warmth with which Van Gogh treated his models is totally lacking in Lautrec's work. Each of the two artists possesses an ambiance peculiar to himself, and even when they portray a similar theme (for instance, a woman seated in a café), we are confronted with two different worlds. Van Gogh's *Femme au Tambourin* (1887), shown with a cigarette and a glass of beer, has a calm, relaxed expression, whereas Lautrec's *la Buveuse* (1888-1889), seated in front of a half-empty bottle of red wine, rests her tired, vaguely nauseated face on her left hand, while her eyes have a fixed, distant look. In this work Lautrec undoubtedly wanted to show us one of those drunken creatures whom he saw haunting the cafés of Montmartre, where he himself had gotten into the habit of going in the evenings to drink. In effect, in 1884 he left the apartment he shared with his mother and went to live in Montmartre. There he parti-

Aristide Bruant
1893
Lithograph

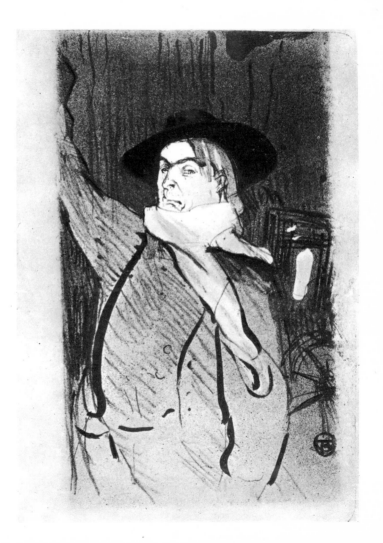

cipated regularly in the night life, visiting the cabarets, the dancing halls, the cafés, the cafés-concerts. He frequented these places not only because he was drinking more and more, but also because he loved this milieu in which he felt more at home, less isolated on account of his infirmity, because it was filled with so many people living on the edge of society who mocked the prejudices and hypocrisies of ordinary bourgeois morality.

One of the cabarets which attracted Lautrec was the Mirliton where the singer Aristide Bruant played. It was not long before the two men became friends and the painter's first woodcut, made two years later in 1885, would illustrate Bruant's song *To Saint Lazare*. Lautrec would do other drawings for the singer and he would also draw scenes of the streets and places which Bruant frequented. As he loved the circus, in 1888 he painted a large oil devoted to the Cirque Fernando on the Boulevard Rochechouart. For the mocking spirit it reveals in its drawing as well as in its composition it is one of the most original oils he ever created.

Around 1890, Lautrec's favorite subjects were provided by the public dances. The one at the Moulin de la Galette had already prompted Renoir to create the most remarkable work of Impressionism (1876). It is significant that Renoir's painting depicts a scene in the open

From the Mirliton to the Moulin Rouge

air under the leaves of a tree while Lautrec's painting makes us enter into a banal, rather sordid room. Without any tenderness brightening their faces, couples jostle against each other, and the young girls are unattractive. Although those in the foreground look silly, they are nonetheless full of life and it is not accidental that Lautrec painted one of them with an orange bun ablaze with provocation. Another girl is exchanging glances with a man whose profile is that of a vulture eyeing its prey.

Yet, the girls who went to the Moulin de la Galette were considered "good." The Moulin Rouge, which opened in 1889, was freer. Professional dancers could be admired there in spectacular shows. One couple, in particular, was applauded whom Lautrec was well acquainted with: Louise Weber, called La Goulue and Jacques Renaudin whose descriptive alias was Valentin le Désossé. They were as ill-matched as they possibly could be. Not only did the man appear thinner and taller than the young woman, but his austere, dismal profile contrasted with her florid face. Moreover, there was something burlesque about the nature and contrasts of their movements. Lautrec never tired following these movements with his eyes, and in *La Danse au Moulin Rouge* (1890) he was at his most eloquent in describing them. The work's composition is so skillful that it gives the impression of being a flash photograph whose effect was totally determined by chance. Yet there is a studied

organization which, though it places the two dancers in the background, displays them with ingenuity.

La Goulue appears in other paintings, but she is not always placed to immediately attract our attention. Sometimes she is less noticeable than the clients of the Moulin Rouge. Lautrec really enjoyed painting the latter, especially those who went out and drank with him. Thus, one of his most superb paintings (*Au Moulin Rouge,*

Self-caricature
1896. Drawing
Albi museum

1892) depicts the lobby of the establishment with a group of his friends at a table (Maurice Guibert, the photographer Sescau, the writer Edouard Dujardin). In the foreground, partly cut off by the frame, there is a young woman as astonishing as an apparition. The violent lighting which projects green shadows on her forehead gives her an ecstatic air. In the background Lautrec himself can be seen next to his cousin Gabriel Tapié de Céleyran, who is almost twice as tall as he. The painter enjoyed being seen with this cousin of his because the disproportion of their heights was comical and by exhibiting his deformity so openly he could face jeers. Undoubtedly he saw others in the same harsh light in which he saw himself. In his portrait of his cousin at the Comédie Française (1894), for example, he unhesitatingly emphasized his tall, stiff stature, his languid gait, his bored, sleepy face.

Lautrec had a few of his models pose in the garden of the père Forest (which was, at the time, next to the Boulevard Clichy). But it was not the open air that primarily interested the artist. In truth, the garden is reduced to a greenish background; the vegetation, the stones, and the ground are only barely sketched in. The artist's curiosity is concentrated on the person who is foreign to the landscape. Consequently these oils tell us less about the model and his life style than those whose décors are a ball or a café.

In 1892 Jane Avril suggested new subjects for

his compositions. Thin, fine, with a bony face and a tired look, this dancer had nothing in common with la Goulue. When she left the Moulin Rouge at the end of her act she looked stiff and sickly, but on stage she was, according to a contemporary, like "an orchid in ecstasy." Furthermore, she danced by throwing her leg to the side rather than up in the air, and turning it faster and faster. Needless to say, Lautrec was sensitive to the strangeness of her movements. And in his painting *Jane Avril Dancing at the Moulin Rouge*, Lautrec showed her very thin legs in such various positions that "the balance of her body was maintained as if by miracle." Like many of the artist's works, this one is painted on cardboard. Lautrec liked this material which he only partially covered with paint so that the cardboard's own tint played an important part in the composition. Besides, he used a thin, chalky, sometimes transparent paste whose effect was both allusive and impetuous. Because of this, the paintings look like sketches and are noteworthy for their spontaneity and freshness. Lautrec's colors have another particularity: they are not soft. He preferred acid, slightly jarring colors in contrast to those which would be pretty and immediately pleasing.

Lautrec's contribution is not restricted to his oils. His woodcuts (posters and prints) are no less meaningful than his paintings. Indeed, they

In the Service of Stars

are sometimes even bolder and more enthusiastic. Let us look at the poster he made in 1891 for the Moulin Rouge in which he once again made use of la Goulue and Valentin le Désossé. The composition is one of his most purposeful, surprising and most effective. An economic organization of color is added to drawing which summarized the form. Each color was selected so that it immediately characterized the person it was depicting. With his grave-digger aspect and loose gait Valentin is a mere purplish silhouette dressed in shadows while la Goulue is brightly colored. Her skirt is like a big white flower topped with a red corsage with white spots and her face is crowned with dazzling blonde hair. Behind her there is an anonymous black crowd whose contours can hardly be distinguished. La Goulue stands out against this backdrop of spectators. In short, Lautrec's means are both basic and refined. No modelling, very few nuances, especially pure tones. Lautrec is the first to have understood that a poster had to be lapidary. Naturally, he was acquainted with Japanese prints, which, since Manet, had impressed and guided more or less all the innovative artists of that period. If, however, he learnt from them and came closer to their spirit than any of his colleagues, he nonetheless remained true to himself. His line evolved with greater freedom than that of the Japanese artists. He was less stylized and far more biting and disrespectful.

In 1893, Lautrec created for Jane Avril (in the Jardin de Paris) an even more attractive poster than the one he had made for la Goulue. She is alone on stage and she is all the more striking as the bright colors (orange, yellow, white, black) are combined in her costumes whereas the colors surrounding her are only half-toned (shades of dull green and gray). In the foreground, the neck of a bass is emerging from the orchestra pit. Not only does it delimit the stage but the movement of its curves makes us think of the rising curtain. It strengthens the impression of surprise and sudden revelation which emanates from Jane Avril seen under a stage lighting free of the slightest trace of shadow. Moreover, the strong hand which is grasping the musical instrument and the fantastic head behind it acts as a repellent force. Immediately, the forearm suggests an oblique line directing our eyes toward the dancer. If we pay little attention to the hand itself, in spite of its size, it is because Lautrec skillfully removed the color from the foreground, which he filled with gray.

Jane Avril is the principal character of another poster (1892). This time she is not on stage but in the room of the *Divan Japonais*, a café-concert where Yvette Guilbert was playing at the time. Seated in the foreground, her slim body molded in a black dress, a feathered hat also perched on her beautiful red hair, she gives an image of elegance and distinction which recalls the women by Kiyonaga. At the same time, she

Yvette Guilbert
1894. Drawing
Cabinet des dessins
Louvre museum, Paris

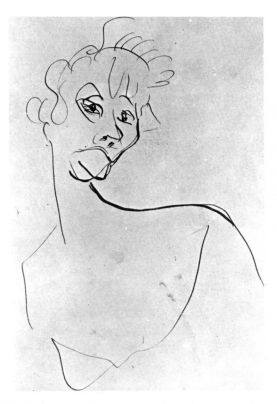

fully belongs to her time and to the milieu she lived in. The same may be said for the man accompanying her, Edouard Dujardin, whose turn of the century dandyism could not have been rendered with greater justice. Altogether the poster abounds in finds no less spiritual than expressive: the orchestra conductor's arms seem

to lead a life of their own; the necks of the basses look like jeering faces; Yvette Guilbert is only a flexible silhouette who is depicted not by her head which is absent from the picture but by black gloves sheathing her thin arms up to her elbows.

One can easily understand the considerable resonance of such posters: they transformed these dancers and singers into stars whose reputation spread far beyond the establishment and the district in which they performed for the public.

Lautrec would also have liked to make a poster for Yvette Guilbert but she refused because she found the sketches he gave her for her approval were not flattering. Indeed, nothing is more foreign to this artist than the idea of beautifying his models. His only concern was to be true to life, and he emphasized the truth he discovered, preferring to shock rather than to please. Thus, his sketches and woodcuts of Yvette Guilbert give her face the aspect of a skinny cat.

Between 1892 and 1895, Lautrec also created posters for Aristide Bruant, for the dancer Loïe Fuller at the Folies Bergère, and for the comic Caudieux at the Petit Casino. He designed them for books (*Reine de joie* and *Babylone d'Allemagne* by Victor Joze), for the newspaper *Le Matin*, and for a confetti factory in London. Each time his works were first-rate. They possessed not only more concision than his paintings but also greater assurance.

The Bordellos Lautrec's non-conformism, his interest for those aspects of life which are normally hidden because they are considered improper; his taste for eroticism as well as the small chances of success his infirmity gave him with women, encouraged him, between 1892 and 1895, not only to frequent bordellos but also to live in two of them for more or less prolonged periods. These houses, one of which was located on rue d'Amboise and the other on rue des Moulins, allowed him to live in the immediate vicinity of prostitutes, to be familiar with all the details of their daily life, to become acquainted with their habits and feelings. They also allowed him to observe nudes whose movements were more natural than those of professional models. Yet it cannot be said that nudes in themselves interested him a great deal. The prostitute's lifestyle and her intimate life absorbed him more than her anatomy.

What Lautrec observed on the rue des Moulins in particular, inspired him until 1896 and even later to execute drawings, woodcuts and paintings that are noteworthy as human documents as well as works of art. Sometimes it is a woman alone pulling her stocking up, taking off her blouse, putting on her pants or corset, combing her hair, washing her neck, or sometimes a woman lying down, dreaming or sleeping. Sometimes we see two friends talking, kissing or resting in the same bed. At other times there are the keepers of the bordello (*Monsieur, Madame*

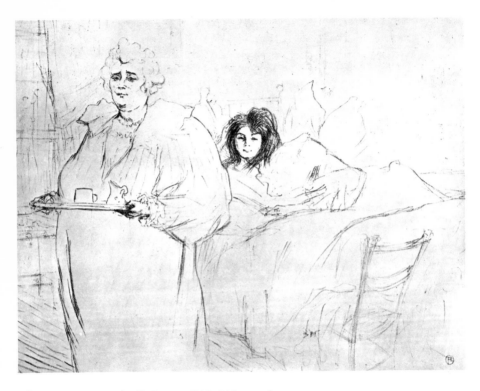

Elles. Mme Baron and Mlle Popo. 1896. Lithograph

et le chien, 1893) flaunting their vulgarity and ugliness.

A few of his works are drawings heightened with color. In others, wide, sudden impetuous brushstrokes give birth to · characters painted

on cardboard of which a large part is visible. Elsewhere, the cardboard and the canvas disappear completely under the colors. It is the case in 1895 when Lautrec painted the residents of the bordello *Au Salon* on the rue des Moulins. Without abandoning the sharpness of his stroke, he gave greater importance to the color zones which were not merly flat painted surfaces as in his posters, but included light and dark contrasts and suggested something in relief.

Seated on large purplish sofas, the women wait for their clients in an atmosphere of spurious luxury and boredom. Their faces, whose individual particularities are emphasized, present hardened traits with passive and at the same time defensive expressions. There is nothing in this work (nor among the others of this series) that does not express the truth of reality. There is no tendency to any judgment. Lautrec was a witness, he never considered himself a moralist, much less a moralizer. Moreover, his testimony avoided sentimentalism and illusion. Though he never thought of condemning these women he did not wish to idealize them. He did, however, look upon them with sympathy. His prostitutes appear less depraved, less degraded than the ones depicted by Degas, although the atmosphere in Lautrec's pictures was generally colder. If they appear more worthy to be considered with a certain affection, it is probably because he found in their company a tenderness which he had sought for, in vain, elsewhere.

In 1896 Lautrec publised a portfolio of lithographs entitled *Elles*. Most of the subject matter had to do with bordellos. However, one of the plates shows the clowness Cha-U-Kao, a robust woman he had already painted in 1895 and whose vigorous forms he liked to emphasize. In one picture we get a glimpse of her in her dressing room taking off her large yellow collarette; in another we see her in the lounge of the Moulin Rouge; she is walking forward with a virile look, her face puffy and serious. In the lithograph of the portfolio *Elles* on the other hand, she is seated heavily, her legs spread apart, a pensive expression on her face. In spite of her obvious fatigue, we are made to feel the strength of a muscular acrobat.

Other stars captured Lautrec's attention. In 1895 it was the singer May Belfort and the dancer May Milton whom he used as models for a number of works, particularly prints and posters. Since 1893 he had taken a lively interest in the theater, and many of his lithographs depict actors and actresses (Sarah Bernhardt, Jeanne Granier, Réjane, Marguerite Moréno, Lucien Guitry, Lugné-Poe, Antoine, Gémier...); a few such works illustrated the programs for Lugné-Poe's Théâtre de l'Œuvre or Antoine's Théâtre Libre *(La Loge au Mascaron Doré, L'Argent)*. The actress Marcelle Lender inspired him to create not only lithographs but also a large painting in which she is seen dancing the bolero in the operetta *Chilpáric* at the Théâtre des Variétés.

Using rich colors and a more pictorial style than usual, Lautrec admirably rendered the suppleness and movement of the dance as well as the effects of the lighting in such a way that in front of this picture we feel transported into a strange and different world. Still in 1895, Lautrec painted two large compositions to decorate the outer walls of the place la Goulue had rented on Place du Trône where she planned to bellydance to attract the crowds. One of these oils displays her performing this exotic dance while the other is reminiscent of her former hits alongside Valentin le Désossé. Though the two works are

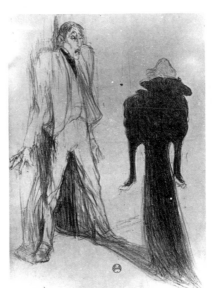

Lugné-Poë
in *L'Image*
1894
Lithograph

considerably damaged, the originality of their organization and the expressive strength of their execution may still be appreciated. The latter is especially apparent in the group of spectators watching the Oriental dance and among whom may be recognized (though they are only seen from the back or in profile) Oscar Wilde, Jane Avril, Lautrec himself and the writer Felix Fénéon.

Lautrec met the above-mentioned writer at *La Revue Blanche*. Indeed, one must not imagine that he spent his time loitering in cafés and bordellos. With Bonnard and Vuillard he was one of the painters who maintained close relations with the literary and artistic avant-garde review which the Natanson brothers directed. He even created a poster (1895) for it which may be included among his masterworks. Misia Godesbka, Thadée Natanson's wife, is seen posing as an ice-skater gliding towards us, her body slightly bent to the right, her left arm lifted to keep her balance, her legs cut off by the edge of the picture. Her fashionable clothes and the refinement of their colors are more important than the expression of her face. On her veiled straw hat is placed an extravagant, baroque headdress of feathers. Lautrec was always attracted by the strangeness and comedy of fashion: time and time again he painted or drew hats that resembled fabulous birds.

At that time, he discovered his passion for a new means of moving quickly: the bicycle. With

his friend Tristan Bernard, who was then the Director of the Buffalo and Seine Velodromes he attended bicycle races and introduced a bicycle in a few of his paintings. He even went so far as to create a poster for the *Chaînes Simpson* (1896). He was also interested in the automobile but he never granted it a noteworthy place in his art.

The Decline

Lautrec's interest in sportshows did not prevent him from drinking. The stronger the drink the more he enjoyed it. In 1897, he was attracted, for a short time, to the bars in the vicinity of the Opéra and the Madeleine. He also liked to go to Montmartre to cafés such as Le Rat-Mort or La Souris where lesbians gathered. Naturally his nightlife and his alcoholic excesses ended up by impairing his health. They also weakened his creative powers. Not that he was incapable of executing any more masterpieces but he would do so only rarely, especially in painting. The posters for *Jane Avril* (1899) and *Marthe dans la Gitane* (1900) do not stand comparison with works of the preceding years. On the other hand, he continued to create beautiful woodcuts. Several of them were destined to illustrate the books *Au pied du Sinaï* by Georges Clemenceau (1898) and *Histoires Naturelles* by Jules Renard (1899). Others consisted of an album devoted to Yvette Guilbert (1898), and of isolated plates on various subjects. In February 1899, shortly after the publication of *Histoires Naturelles*, Lau-

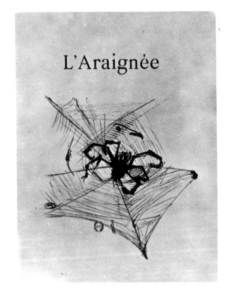

Histoires naturelles of Jules Renard
1899. Cover

trec suffered an attack of delirium tremens which required his confinement in a rest home in Neuilly. However, with no liquor, he quickly recovered his artistic powers, and he began drawing. He executed fifty works that brought to life memories of the circus: horsewomen, horsemen, acrobats, clowns, performing dogs... As he ordinarily used colored crayons for these works, the color scale is sparing and delicate. As for the stroke, it is lighter than before, less

incisive, less descriptive. Though his works are not devoid of humor, they are more respectful than those of the preceding years, as if the artist, who had seen reality crumble during his fits, were making an effort to get a more objective grip on it. But these drawings may also be explained by something else: Lautrec wanted to prove to his doctors that his memory had not been altered (at first it seemed he had lost it), that, on the contrary, it still permitted him to accurately draw scenes he had observed before. Nevertheless, there is something unreal about these drawings, probably because of the emptiness which surrounds the animals and people he has depicted, probably also because of the cold, white light that is diffused on a number of sheets and which leaves only bare shadows on the page.

After two and half months of confinement, Lautrec was able to leave the rest home but, henceforth, he would always have a man, Paul Viaud, to watch over him and prevent him from drinking again. Taking up his artistic work again, he created, in particular, woodcuts inspired by horse races. In the summer of 1899, in a bar for sailors at Le Havre, he saw a barmaid with a milkwhite face and blonde hair whose portrait he enthusiastically drew (*Anglaise du Star*). The work is radiant; there is nothing morbid or cutting about it. It is a homage to the bursting freshness of life made by someone who has just come dangerously close to madness.

Such a painting, however, was an exception.

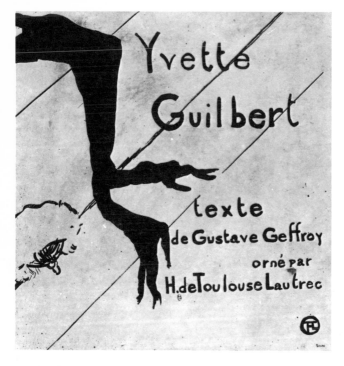

Yvette Guilbert
Text by Gustave Geffroy
1894. Cover

Curiously enough, at the end of his career, Lautrec resorted to the pictorial genre which—he constantly proved it—was so ill suited to his talents. Moreover, his color is subdued; dejection, probably the reflection of weakened strength, is also apparent. The drawing has lost its biting sharpness. In a work such as *La Modiste* (1900), it even seems that the strokes and colors are touched with tenderness. This trait could not

be found in his previous works—and it would never be found again.

Furthermore, despite Viaud's vigilance, he began to drink again and his health continued to deteriorate. In the summer he returned to his mother's in Malrome as he had done the previous year. Then he settled in Bordeaux. He liked to go to the theater and he drew or painted scenes from *La Belle Hélène* by Meilhac and Halévy as well as from *Messaline* by Isidore de Lara. Once again, he displayed the amusing disrespect so characteristic of him; his style no longer had the caustic self-assurance of former days. At the end of April 1901, he came back to Paris where he shortly started working on a painting he would never finish, *Un Examen à la Faculté de Médecine*, that is, his cousin Gabriel Tapié de Céleyran passing his doctoral thesis. His style, this time, was more pictorial than ever. Built with spots of color, the shapes have something massive about them. Contrasting with the dominant colors, black and green, there are clear tones and a red whose vividness is subdued but insistent. It has been justly pointed out that this picture anticipates Rouault, although the latter's work is more vehement and more pathetic.

In July, 1901, Lautrec left Paris once again for Arcachon. Shortly thereafter, he suffered an attack which left him paralyzed. Carried home to his mother's, he died in Malrome on September 9, 1901. There is no doubt that he did everything to destroy himself. But he also

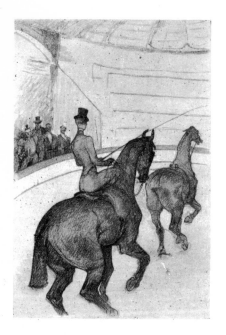

At the Circus
horses in tandem
1899. Drawing

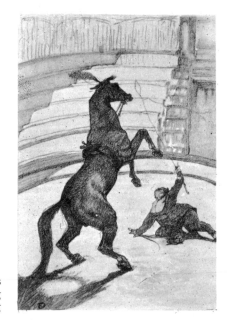

At the Circus
horse prancing
1899. Drawing

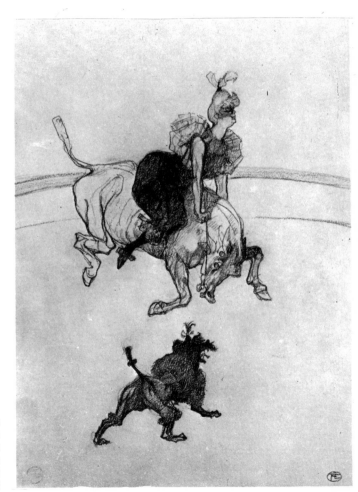

At the circus
The female clown
Cha-U-Kao as an
equestrienne
1899
Coloured pencil

did everything to deny his infirmity, or at least to live intensely in spite of the obstacles it presented him with. His art reflects his resolution not to yield to the miseries of his body. No complaint may be discovered, no attempt to arouse our pity for his fate or the misfortunes of others. In all his work, he asserts that life is a passionate experience for those who are willing to look at it with passion. But passionate does not necessarily mean exalting. Lautrec never thought the world of pleasure was anything but a brilliant façade. The partygoers and drinkers who gathered in cafés to escape solitude succeeded in doing so only momentarily, like the painter himself who sought in vain to flee himself. Lautrec was too lucid, too deeply disillusioned to indulge in an artificial optimism. He could not help but see the truth of life, and he could not keep himself from expressing it, event if this meant being cruel and spiteful. Considering his physical state, it is not difficult to understand why he wished to revenge himself on life by means of bitter caricatures. Yet though he never hesitated to emphasize and even ridicule the traits of the characters he portrayed, he transcended caricature and mere journalistic cartoons by the sensitivity, expressive power, liveliness and accuracy of his drawing. He transcended them also by the intensity with which he evoked the milieu he lived in, the milieu in which his art flourished and in which he spent himself so desperately.

Translated by
Wade Stevenson

LIST OF PLATES

PLANCHES

PLATES

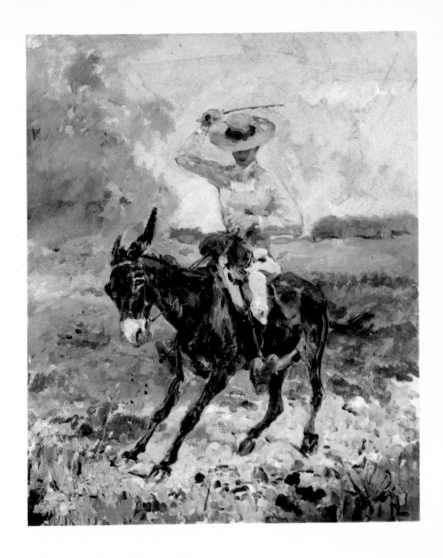

1 Raoul Tapié de Céleyran. 1881.

2 Le Comte Alphonse de Toulouse-Lautrec conduisant son mail-coach à Nice. 1881.
Count Alphonse de Toulouse-Lautrec driving his Mail-Coach to Nice.

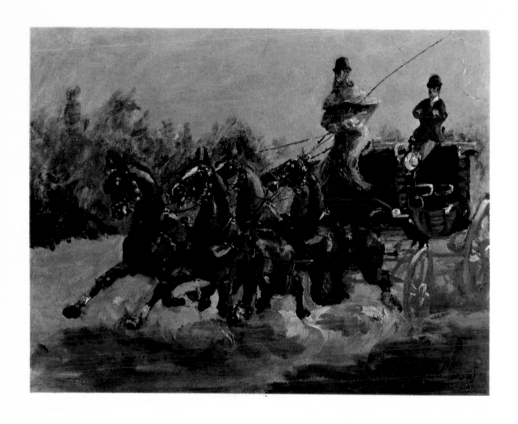

3→

La Comtesse A. de Toulouse-Lautrec dans le salon du château de Malromé. 1887.
Countess A. de Toulouse-Lautrec in the Salon at Malromé.

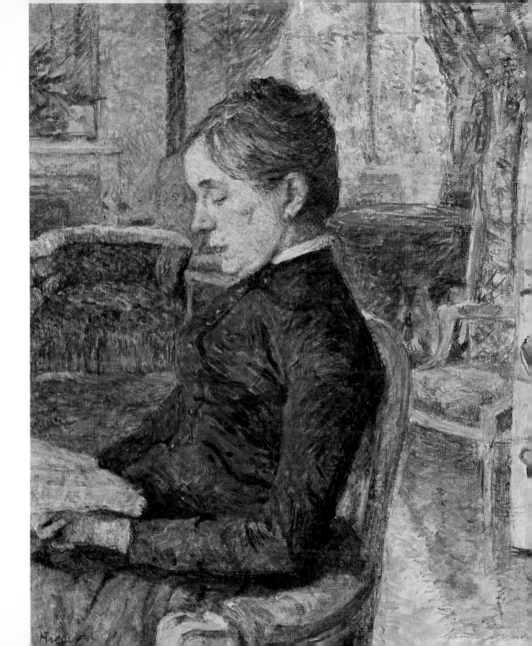

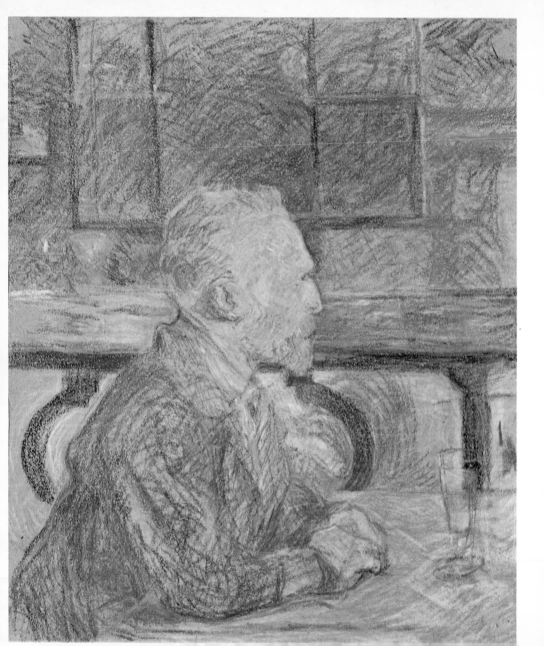

←4
Portrait de
Vincent van Gogh.
1887.

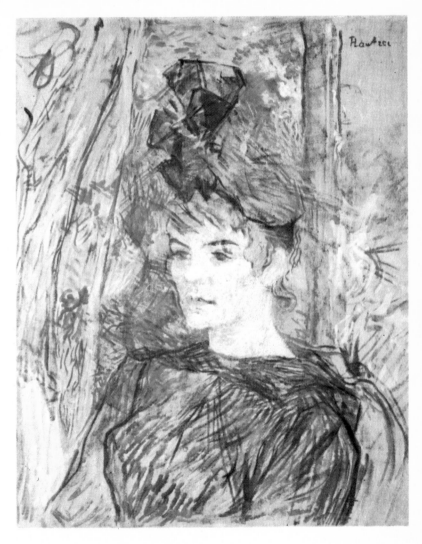

5 Portrait de Suzanne Valadon. 1885.

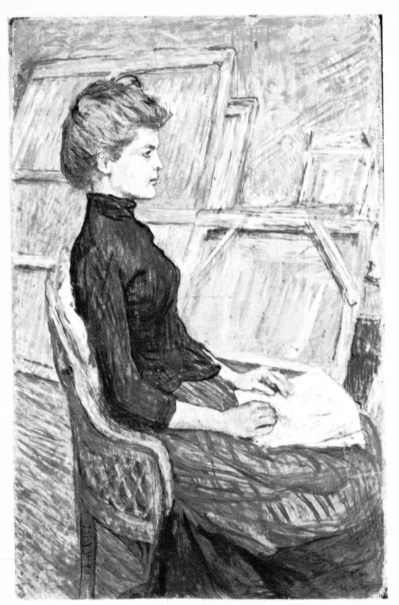

6
Portrait d'Hélène V.
1888.

7
Femme assise
de dos.
1888.
Seated Woman,
seen from the Back.

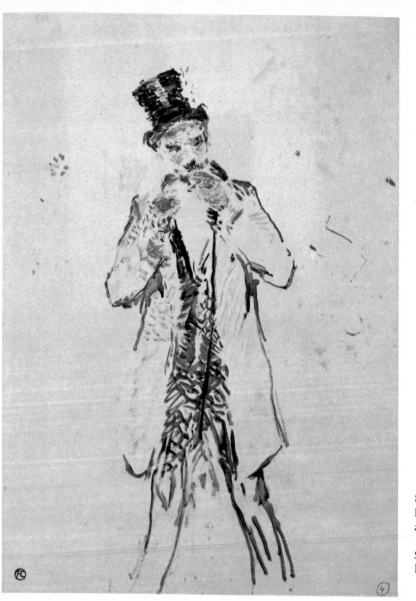

8
Monsieur debout
allumant un cigare.
1885.
Standing Man
lighting a Cigar.

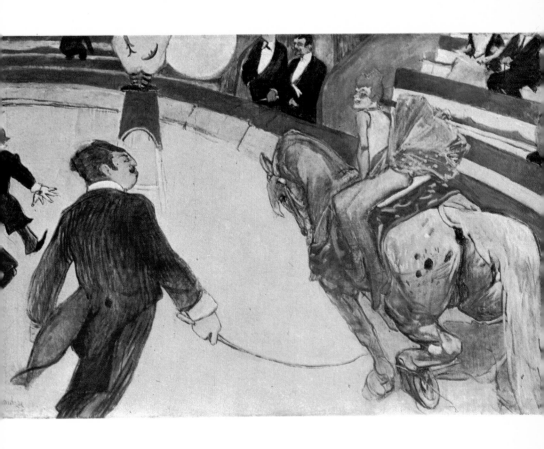

9 Au cirque Fernando. L'écuyère. 1888. The Equestrienne.

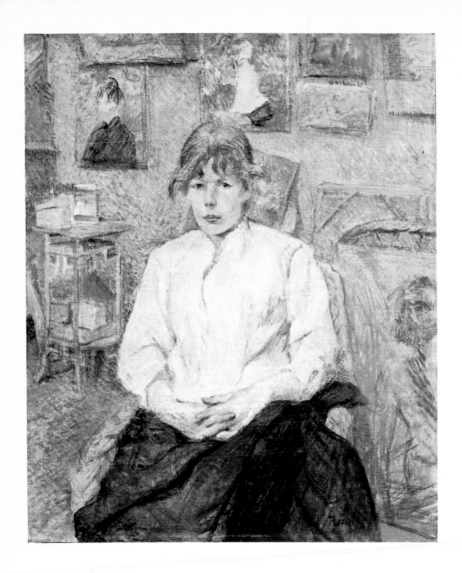

10 Femme dans l'atelier. 1888. Young Woman in a Studio.

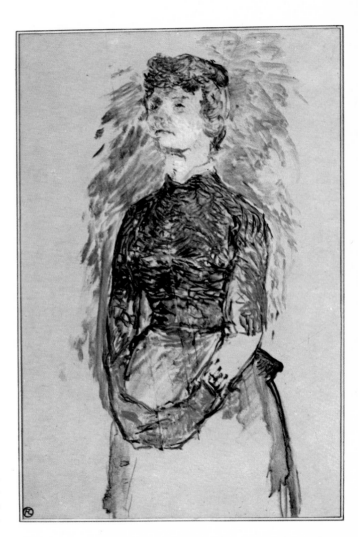

11
Femme debout.
1888.
Woman standing.

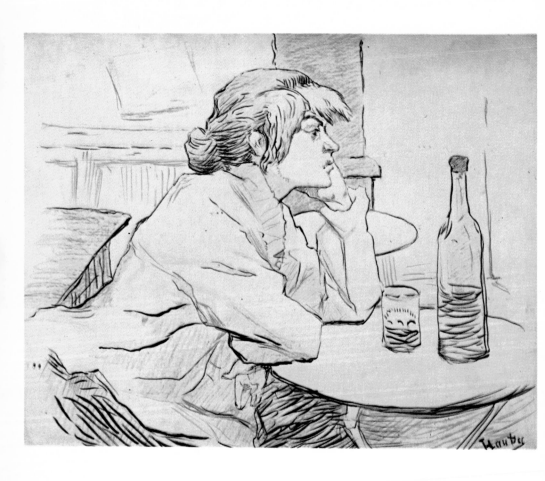

12 La Buveuse ou la Gueule de bois. 1889. The Drinker or the Morning after.

13
A Saint-Lazare.
1886.

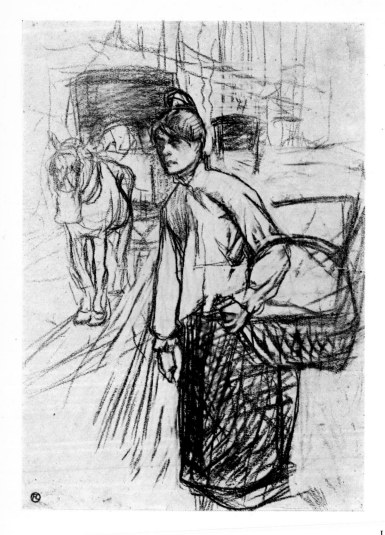

14
La Blanchisseuse.
1889.
The Laundress.

15→
La Blanchisseuse. 1889.
The Laundress.

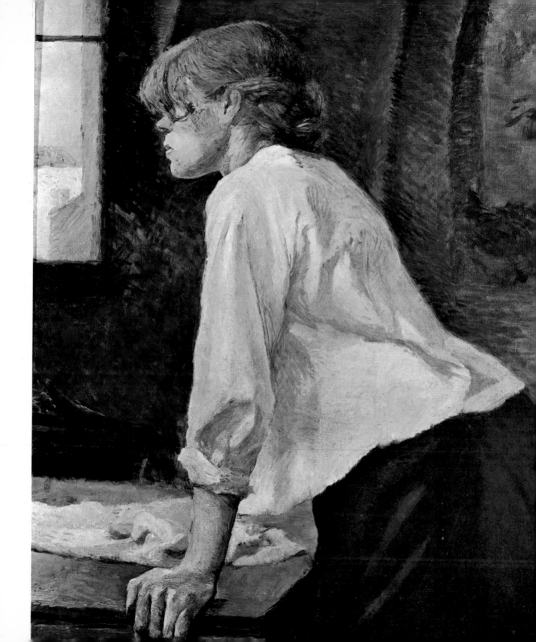

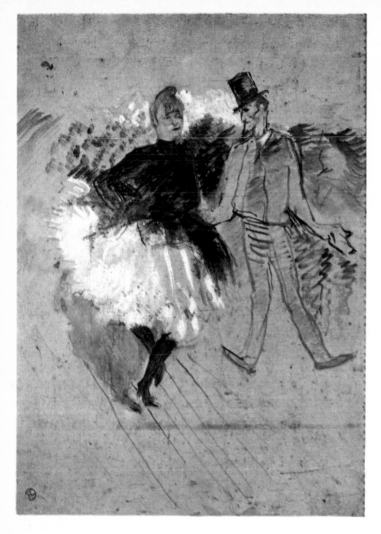

16
Au Moulin de la Galette.
La Goulue et
Valentin le Désossé.
1887.

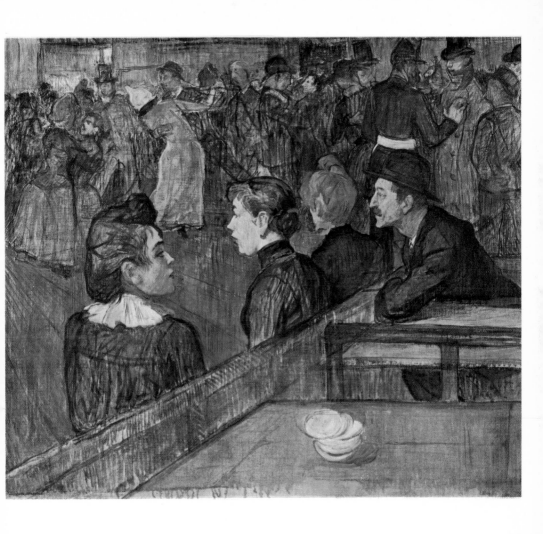

17 Au bal du Moulin de la Galette. 1889.

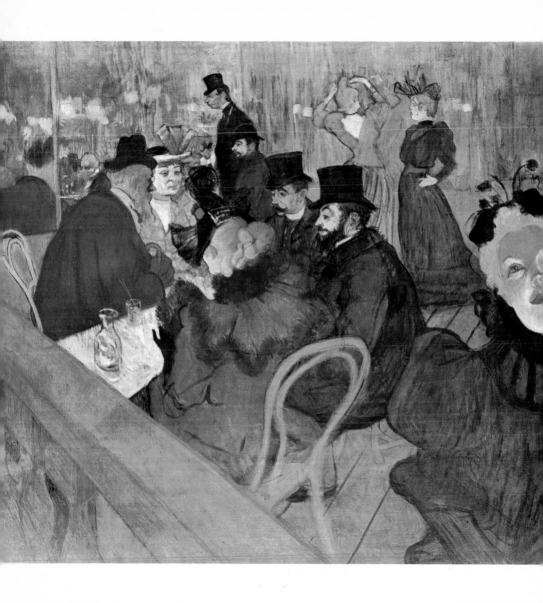

18
Au Moulin Rouge.
1892.

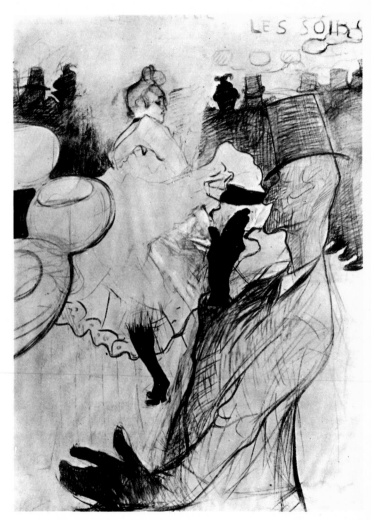

19
La Goulue
et Valentin le Désossé.
1891.

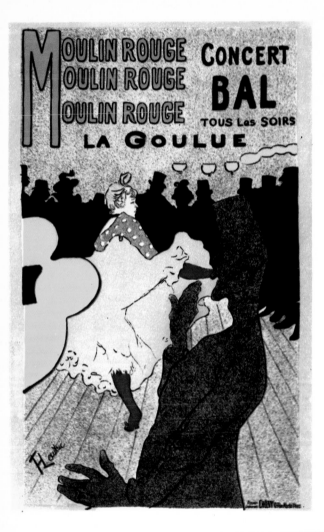

20
Moulin Rouge. Affiche.
1891.
Poster.

21→
Moulin Rouge. Affiche.
Détail. 1891. Poster.

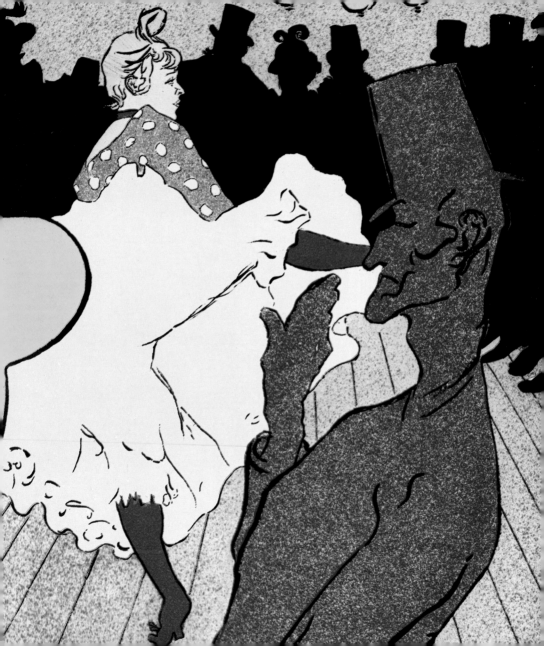

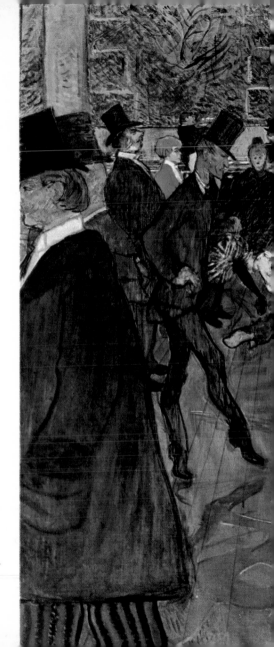

22
La Danse au Moulin Rouge.
1890.

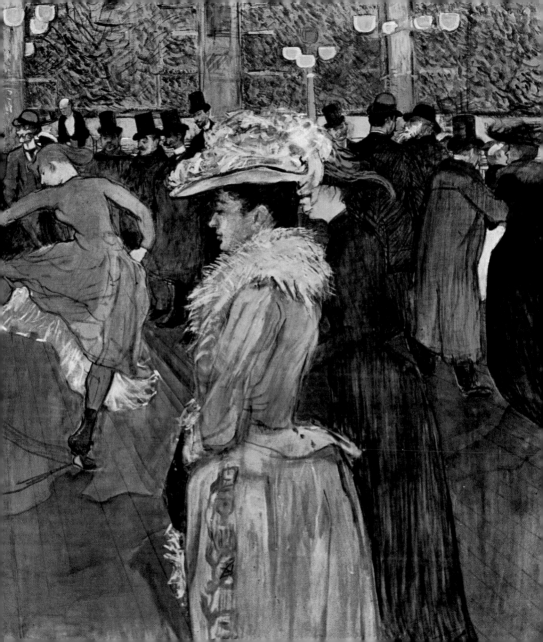

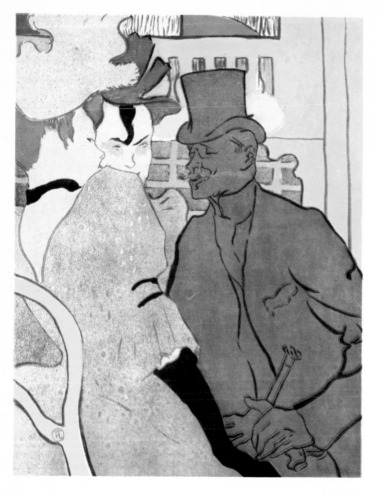

23
L'Anglais au
Moulin Rouge.
Lithographie.
1892.
The Englishman at
the Moulin Rouge.

24→
La Goulue entrant
au Moulin Rouge.
1892.

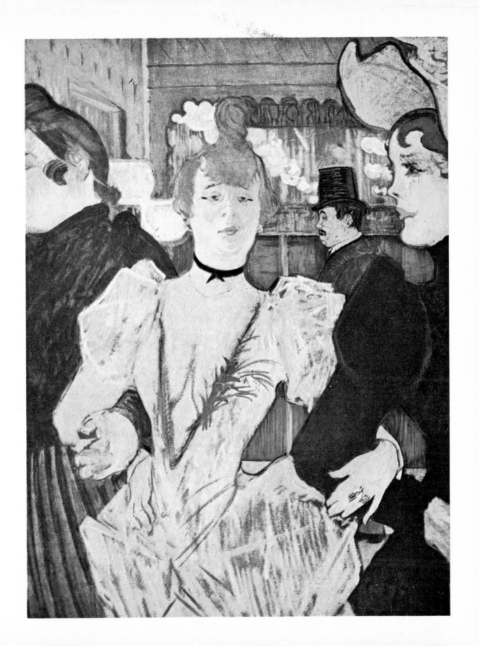

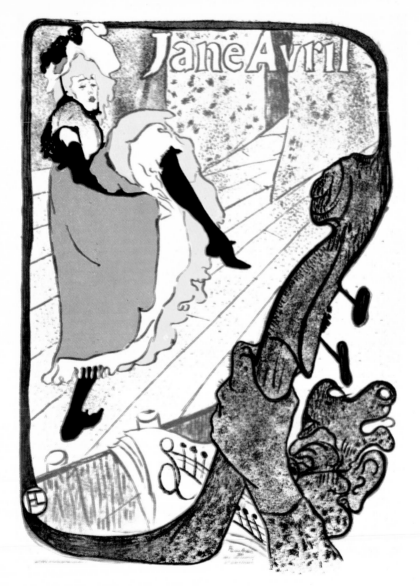

25
Jardin de Paris.
Jane Avril.
Affiche. 1893.
Poster.

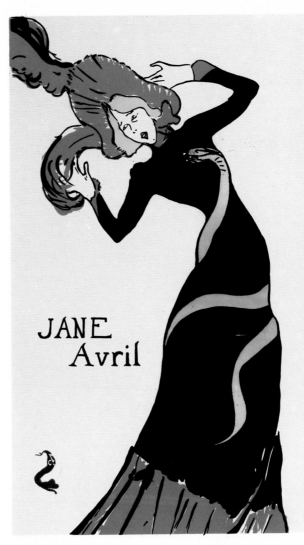

JANE
Avril

H Stern, Paris

1899

26
Jane Avril. Affiche.
1899.
Poster.

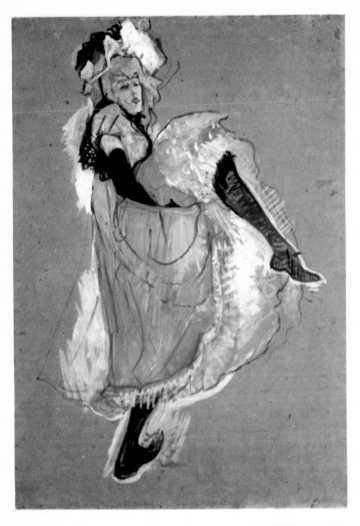

27
Jane Avril dansant.
1892.

28→
Jane Avril sortant du
Moulin Rouge. Détail. 1892.
Jane Avril leaving
the Moulin Rouge.

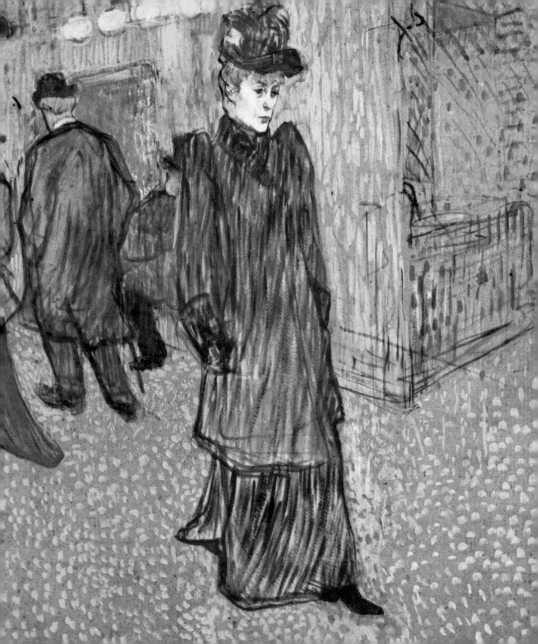

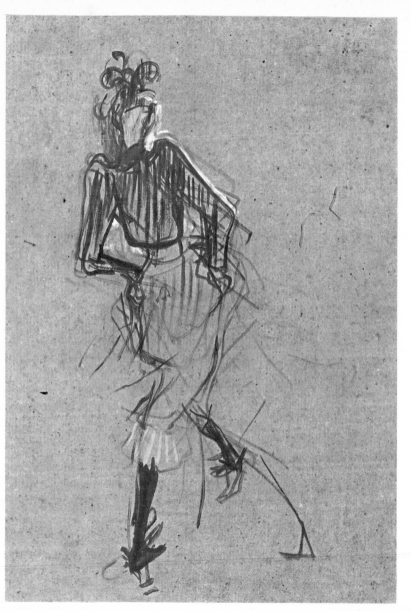

29
Jane Avril. Étude.
1892.
Study.

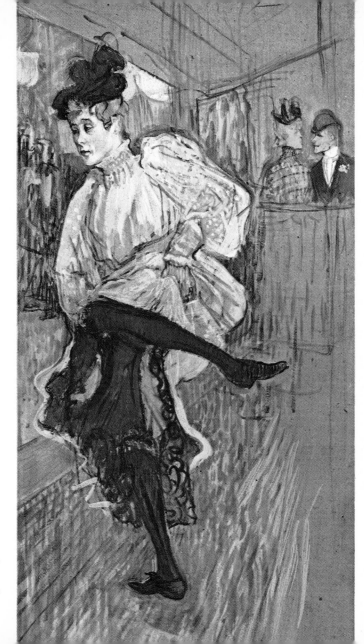

30
Jane Avril dansant.
1892.

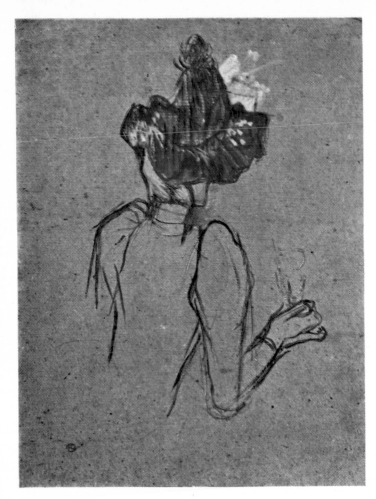

31
Jane Avril de dos.
1892 ?
Jane Avril
from the Back.

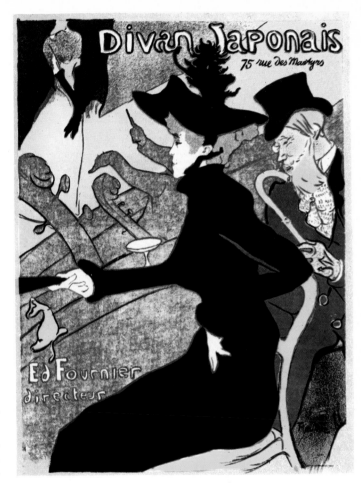

32
Divan japonais.
Affiche.
1892.
Poster.

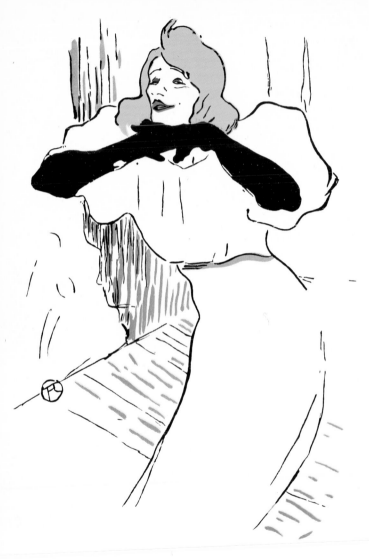

33
Yvette Guilbert.
1894.

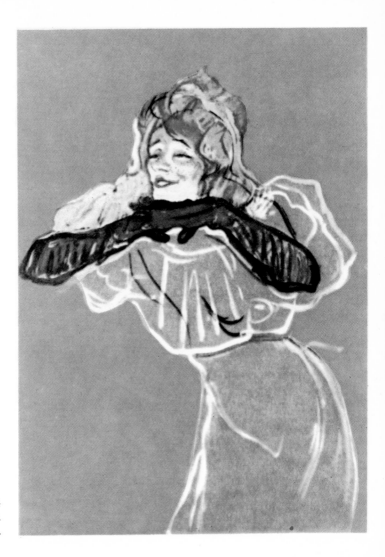

34
Yvette Guilbert.
1894.

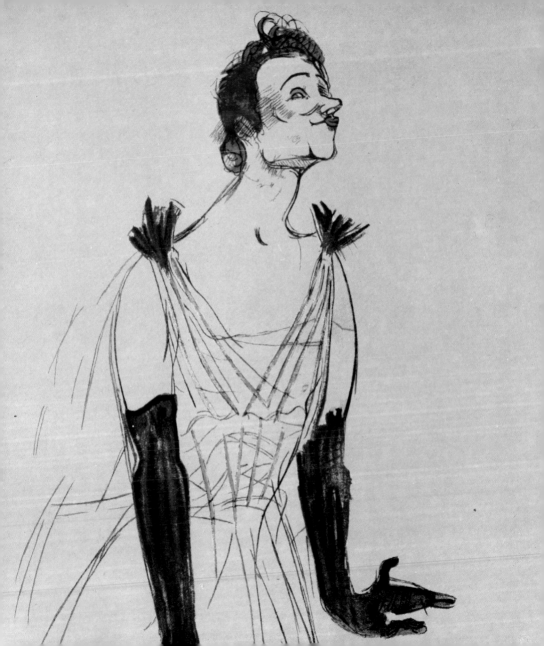

36
Yvette Guilbert
saluant le public.
1894.
Yvette Guilbert
taking a Curtain call.

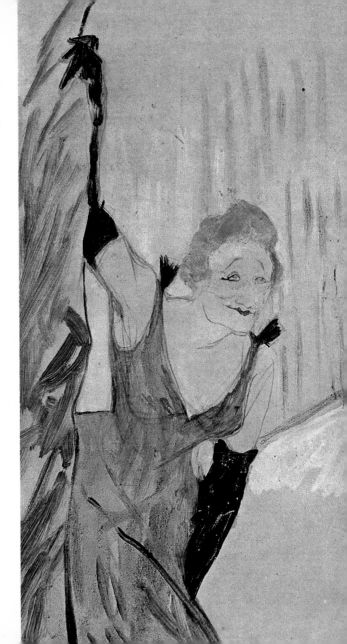

←35
Yvette Guilbert.
Détail.
1894.

37 Le Lit. 1892. In Bed.

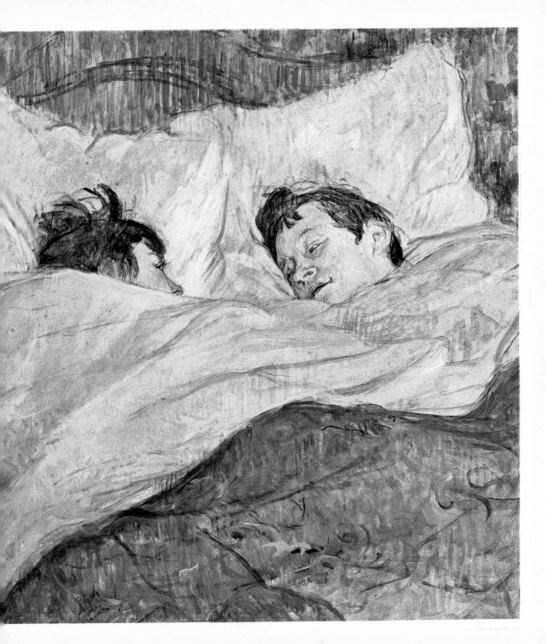

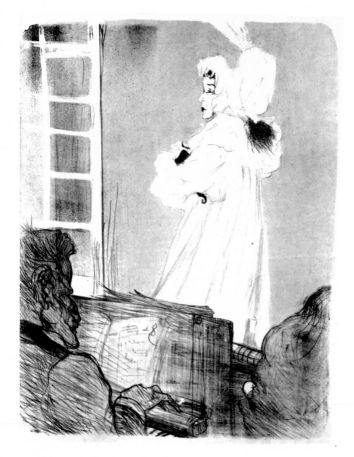

38
May Belfort.
Lithographie.
1895.

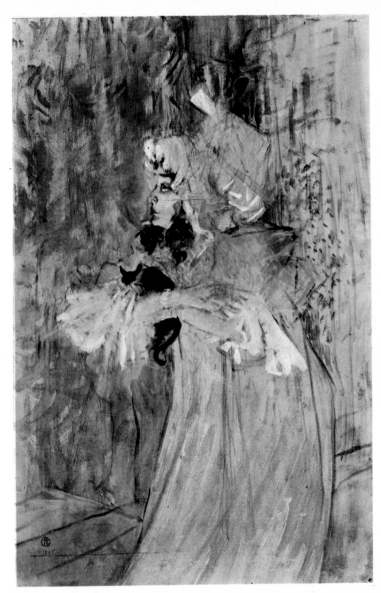

39
May Belfort.
1895.

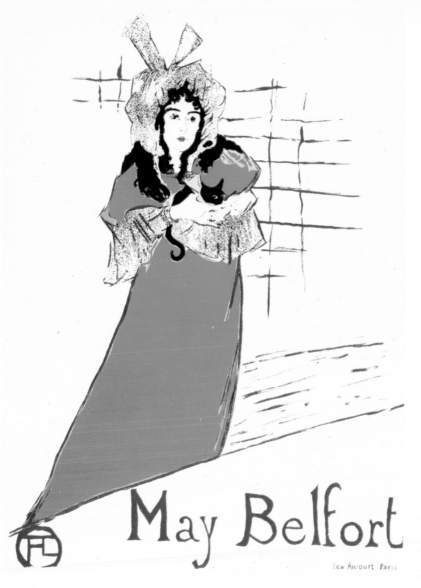

May Belfort

Eew Ancourt. Paris

40
May Belfort.
Affiche.
1895.
Poster.

41
May Milton.
Affiche.
1895.
Poster.

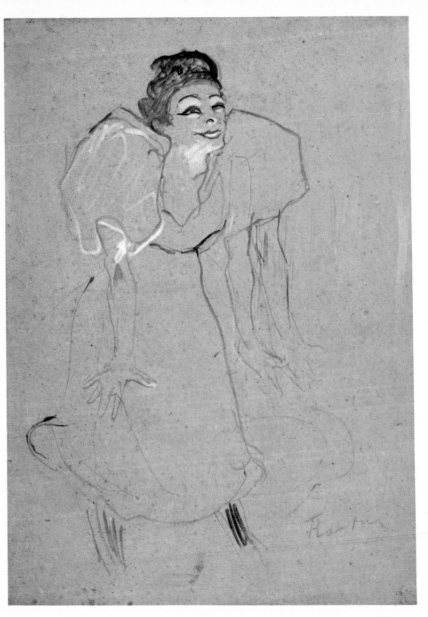

42
Mademoiselle
Polaire.
1895.

43
May Milton.
1895.

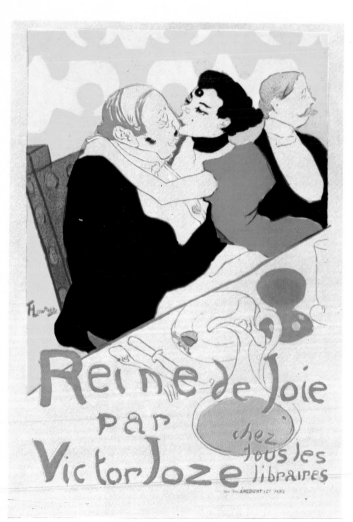

44
Reine de Joie.
Affiche.
1892.
Poster.

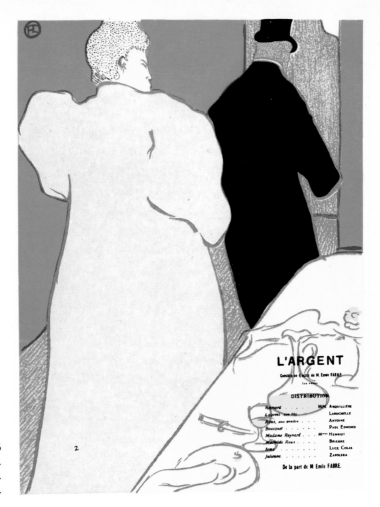

45
L'Argent.
Lithographie.
1893.

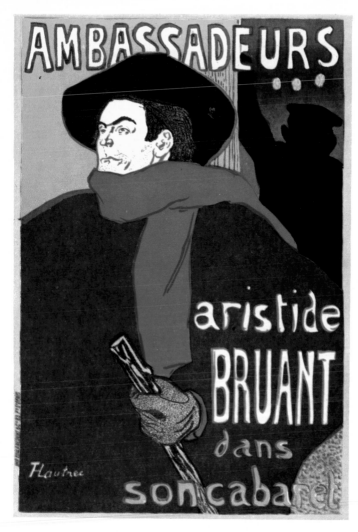

46
Ambassadeurs.
Aristide Bruant
dans son cabaret.
Affiche. 1892.
Poster.

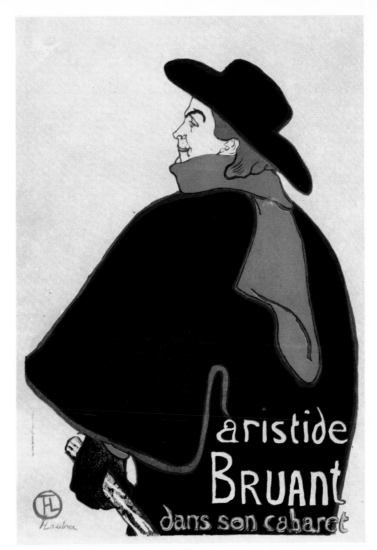

47
Aristide Bruant
dans son cabaret.
Affiche.
1893.
Poster.

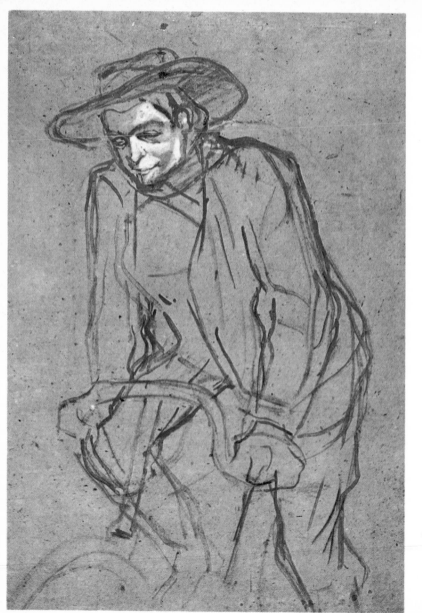

48
Bruant
à bicyclette.
1892.
Bruant riding
a Bicycle.

49→
Ambassadeurs.
Aristide Bruant
dans son cabaret.
Affiche. Détail.
1892.
Poster.

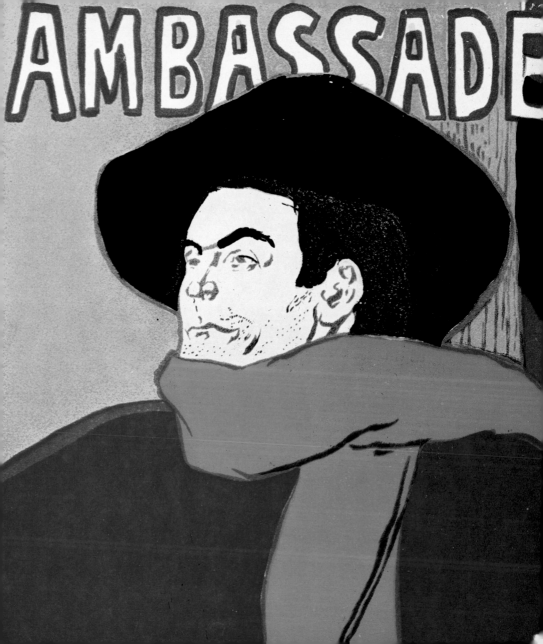

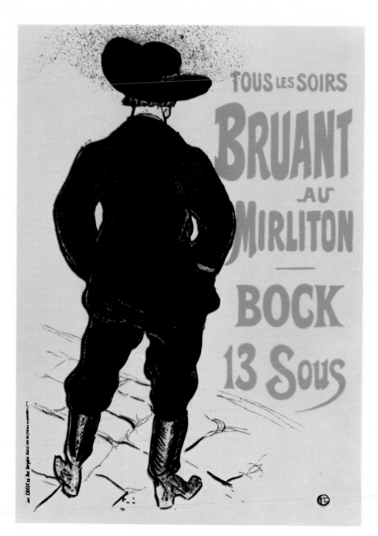

50
Bruant
au Mirliton.
Affiche.
1894.
Poster.

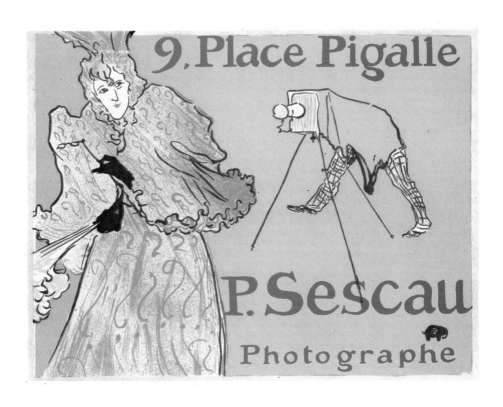

51 P. Sescau, photographe. Affiche. 1894. Poster.

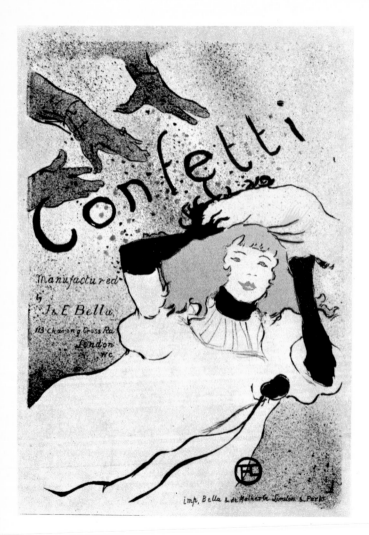

52
Confetti.
Affiche.
1893.
Poster.

53→
La Loïe Fuller
aux Folies-Bergère.
Détail. 1893.

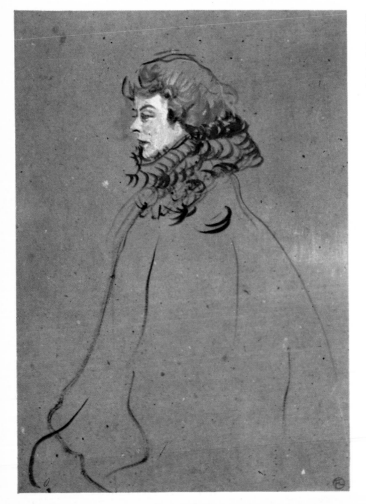

54
Portrait de femme
à la fourrure.
Vers 1892-1894.
Portrait of a Woman
with a Fur.

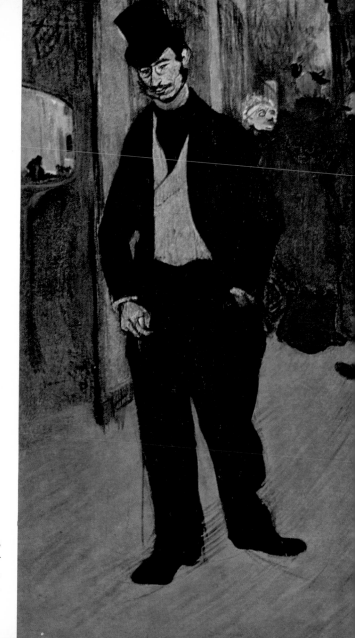

55
Le Docteur
Gabriel Tapié de Céleyran.
Détail. 1894.

56　La Goulue et Valentin le Désossé. Lithographie. 1894.

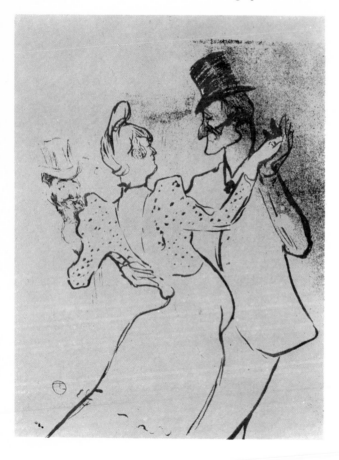

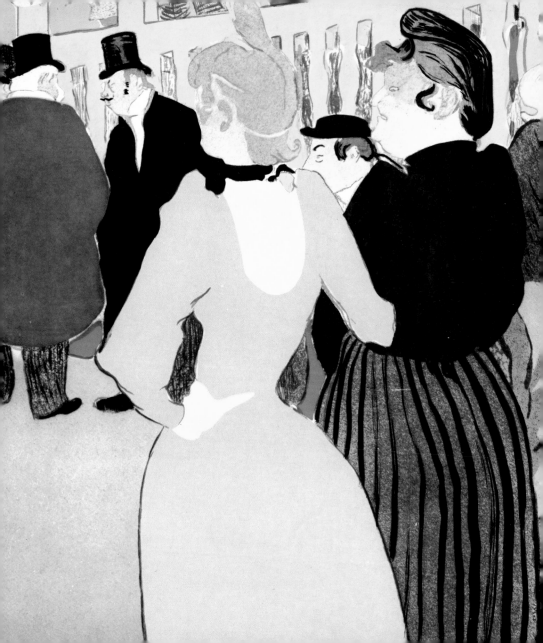

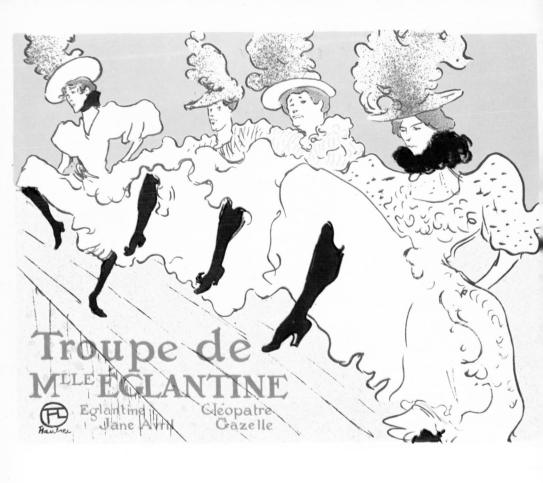

58 La Troupe de Mlle Églantine. Affiche. 1896. Poster.

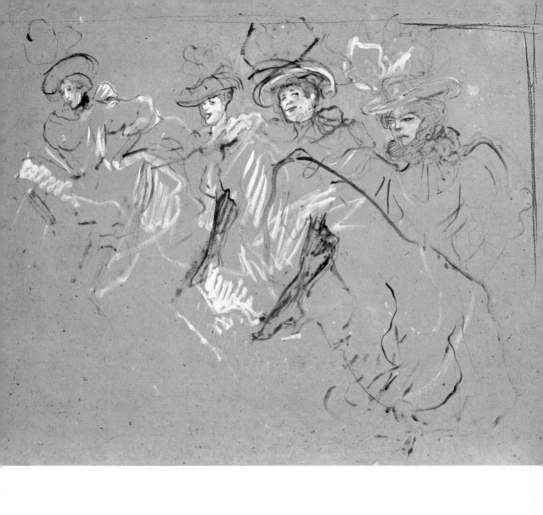

59 La Troupe de Mlle Églantine. 1896.

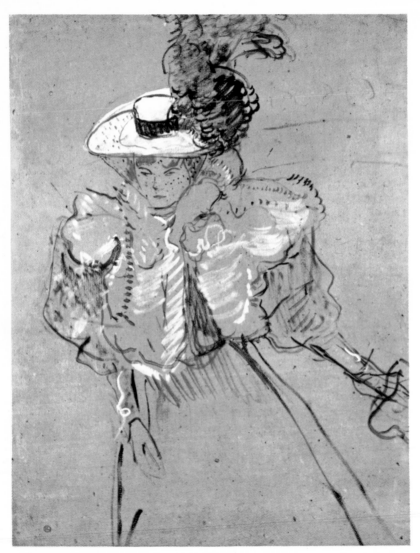

60
Misia Natanson.
1895.

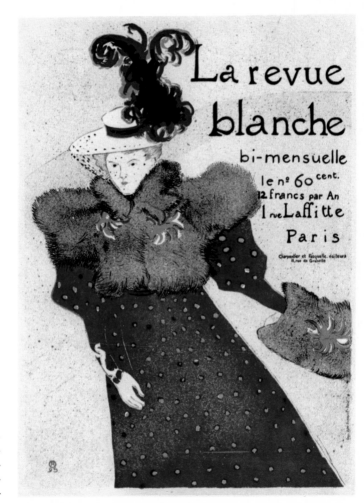

61
La Revue blanche.
Affiche.
1895.
Poster.

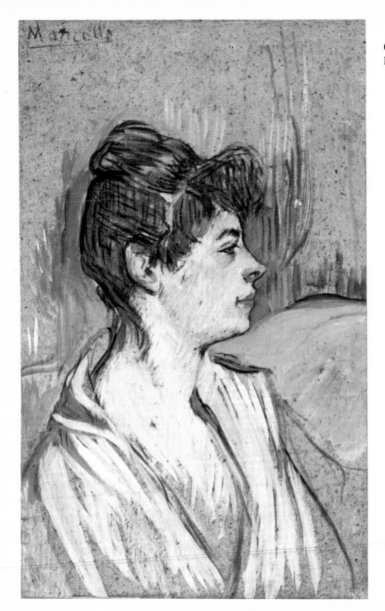

62
Marcelle.
1894.

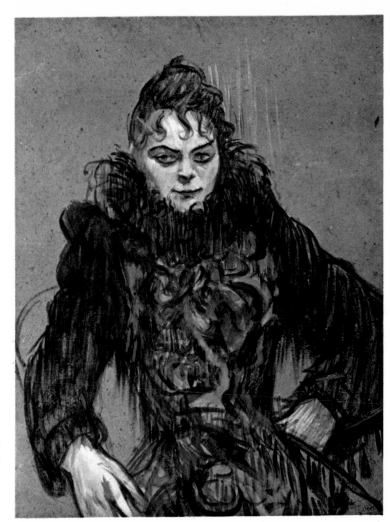

63
La Femme
au boa noir.
Vers 1892.
Woman with
a Black Boa.

64
Fillette nue.
1893.
Naked Girl.

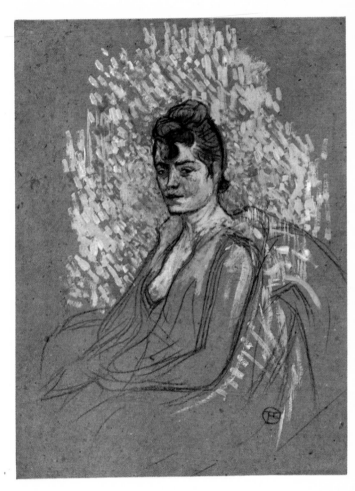

65
Femme assise.
1893.
Seated Woman.

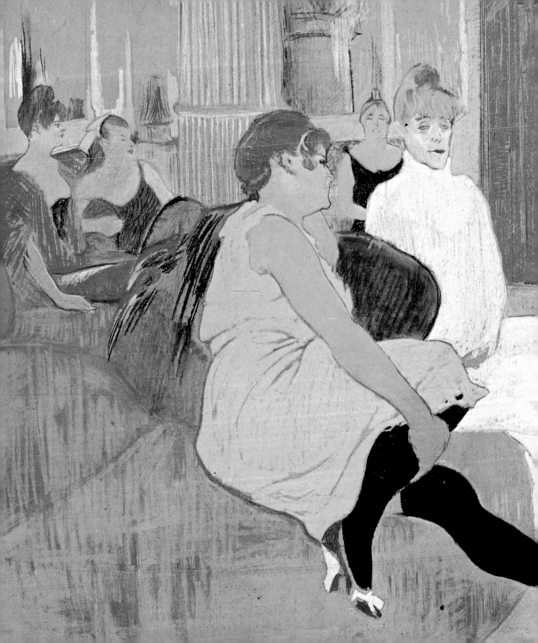

←66
Esquisse pour la
« Rue des Moulins ».
1894.
Sketch for the
« Rue des Moulins ».

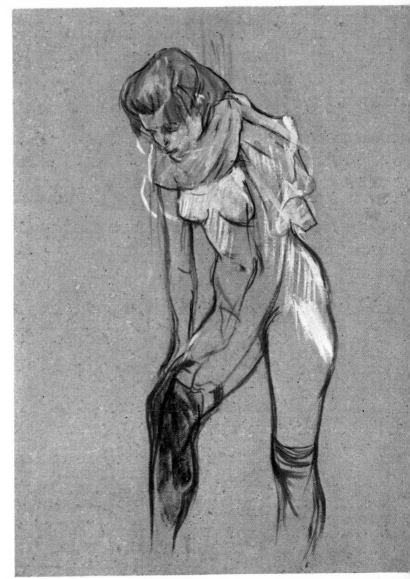

67
Femme qui tire
son bas.
1894.
Woman pulling
on her Stocking.

68
Au salon de la rue des Moulins.
1894-1895.

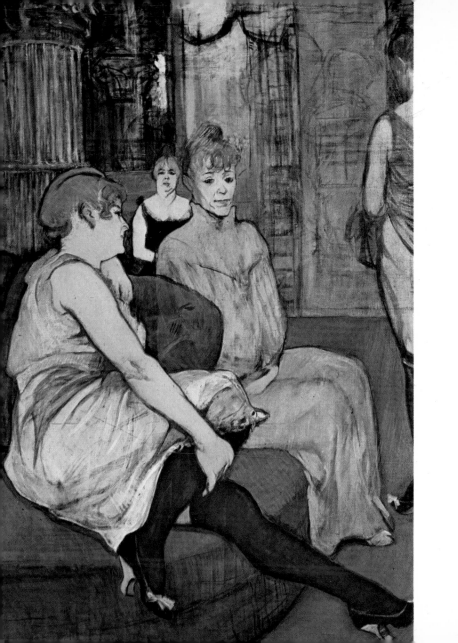

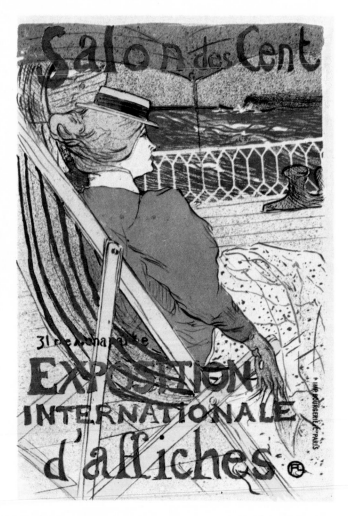

69
Salon des Cent.
Affiche. 1896.
Poster.

70
Au concert. Affiche.
1896.
At the Concert.
Poster.

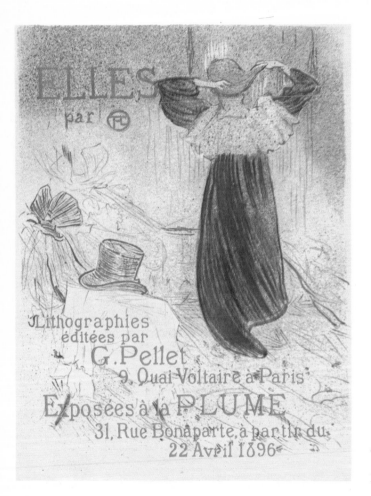

71
« Elles ». Affiche.
1896.
Poster.

72
La Toilette.
1896.

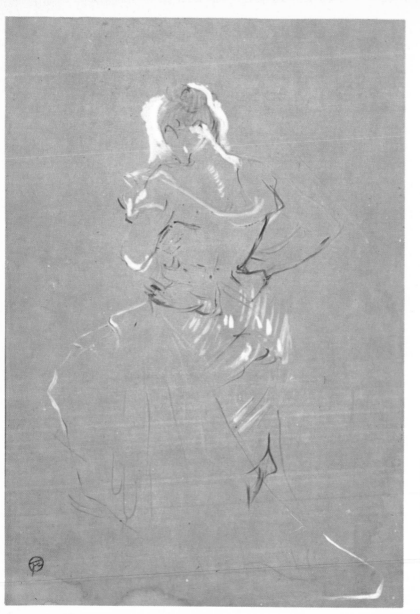

73
Femme mettant
son corset.
Conquête
de passage.
1896.
A Passing Fancy :
Woman putting on
her Corset.

74 Femme se peignant. 1896. Woman combing her Hair.

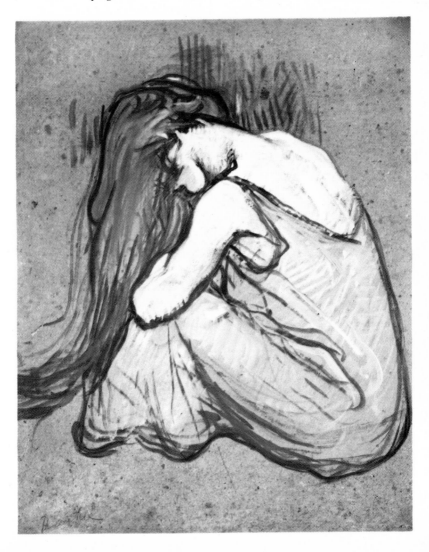

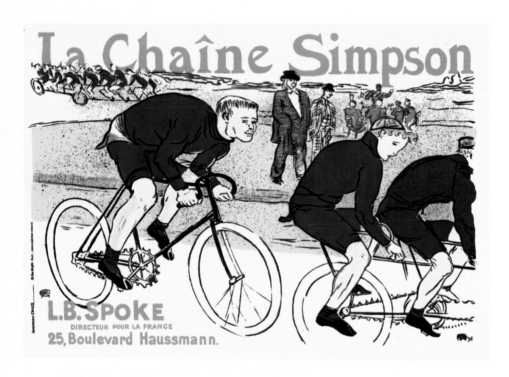

75 La Chaîne Simpson. Affiche. 1896. Poster.

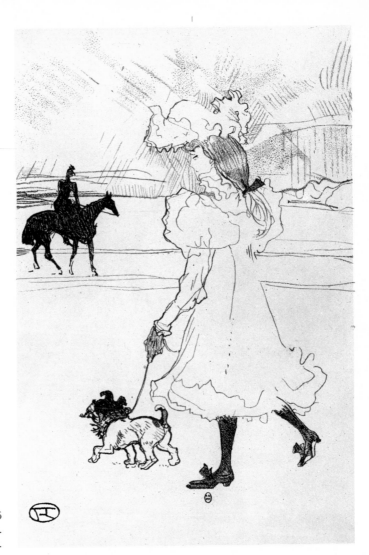

76
Au Bois.
Lithographie. 1899.

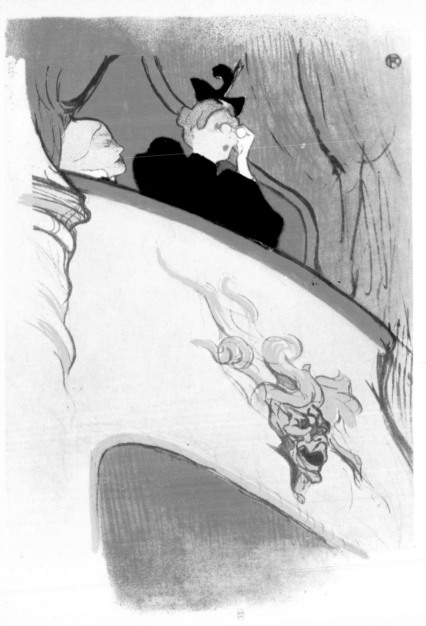

77
La Loge au
mascaron doré.
Lithographie.
1894.
Theatre Box
with a Gilded
Mask.

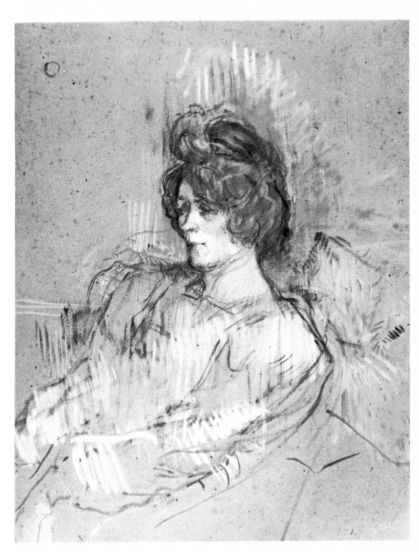

78
La Loge. 1894.
Theatre Box.

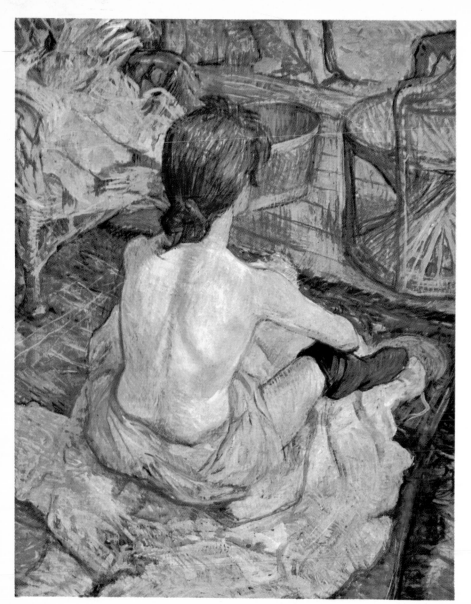

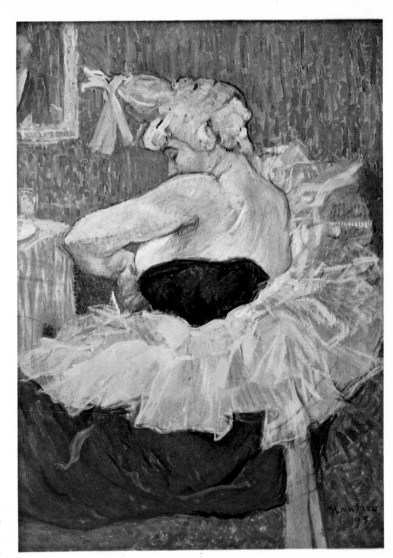

80
La Clownesse
Cha-U-Kao.
1895.

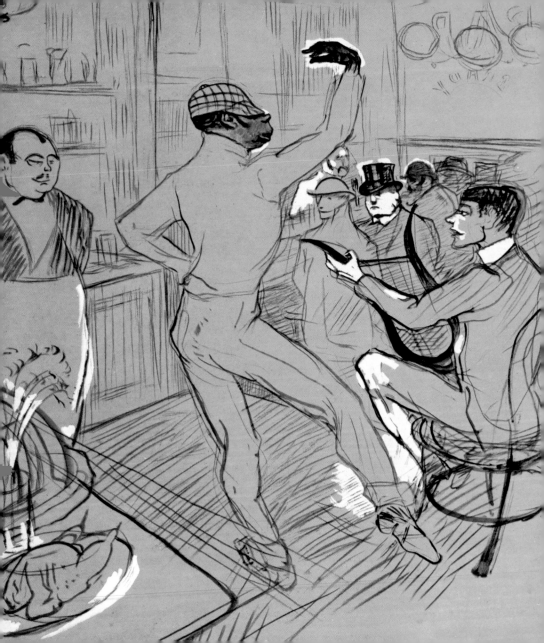

←81 Chocolat dansant. 1896.

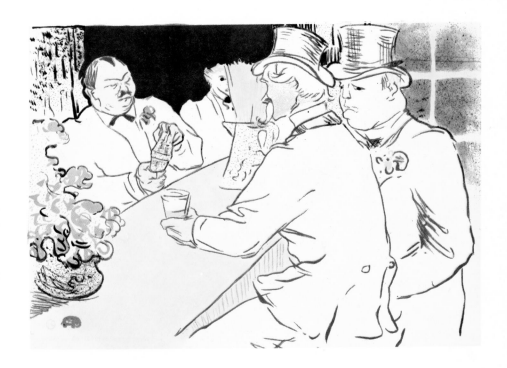

82 Irish and American Bar. The Chap Book. 1896.

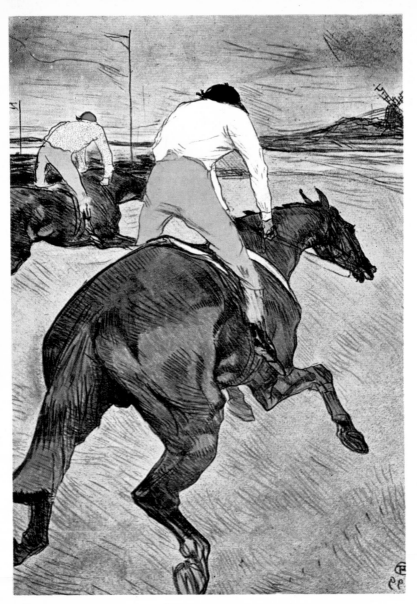

83
Le Jockey.
Lithographie.
1899.

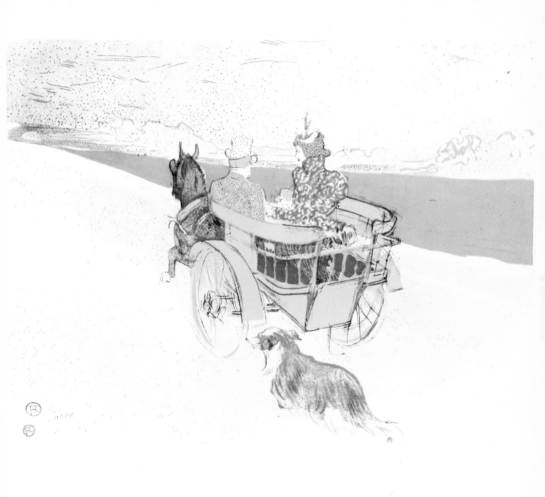

84 La Partie de campagne. Lithographie. 1897. Country outing.

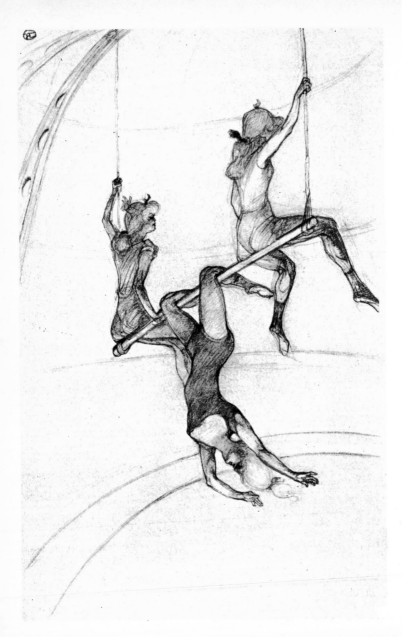

85
Au cirque.
Le trapèze volant.
1899.
The Flying Trapeze.

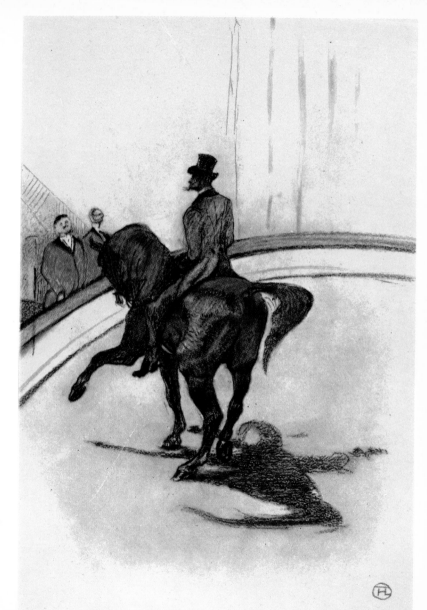

86
Au cirque.
Haute école.
1899.
Circus Horse.

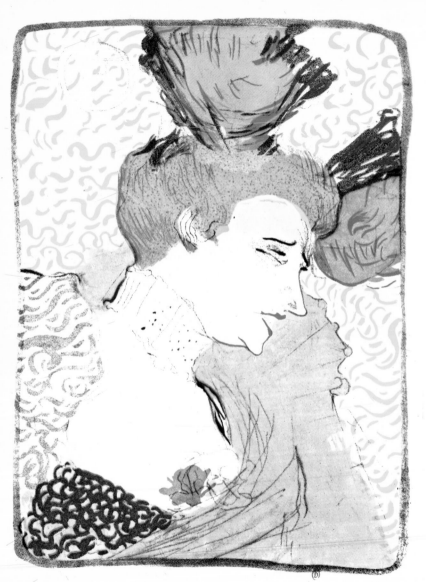

87
Marcelle Lender.
Lithographie.
1895.

88→
« Messaline »
à l'Opéra
de Bordeaux.
1901.

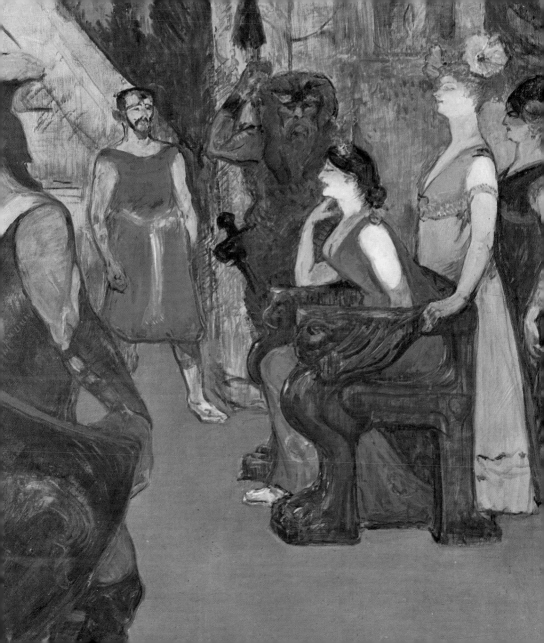

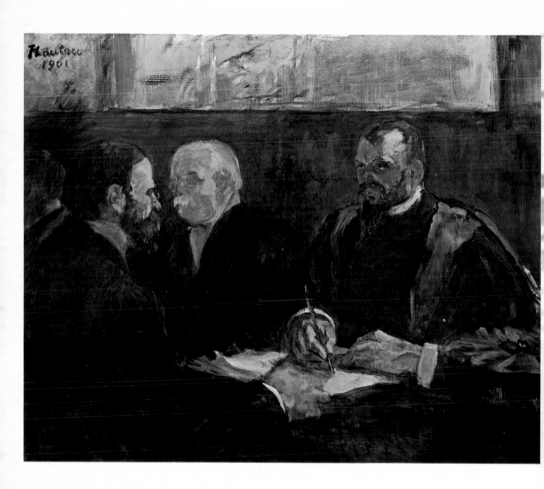

89 Un examen à la Faculté de médecine de Paris. 1901.
An Examination at the School of Medicine, Paris.

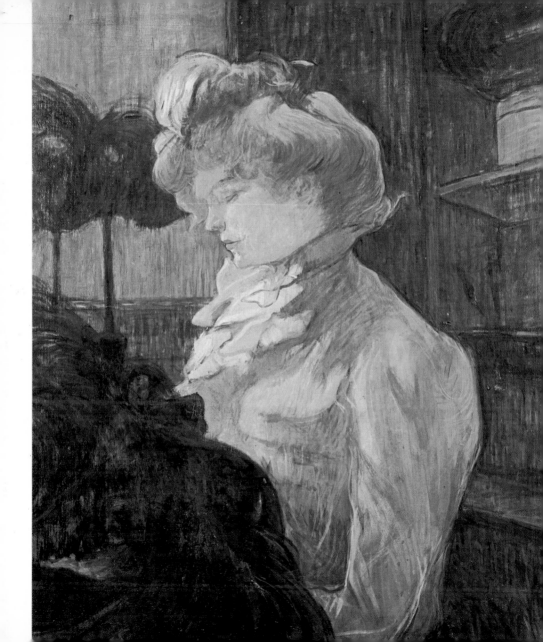

H4

J Watchman